Calligraphy
in the
Copperplate Style

Herb Kaufman
and
Geri Homelsky

DOVER PUBLICATIONS, INC.
NEW YORK

Calligraphy in the Copperplate Style is a new work, first pub-
lished by Dover Publications, Inc., in 1980.

International Standard Book Number: 0-486-24037-1
Library of Congress Catalog Card Number: 80-66324

Manufactured in the United States of America
Dover Publications, Inc.
180 Varick Street
New York, N.Y. 10014

Contents

Introduction

Copperplate lettering is that branch of calligraphy, often called *script*, which is characterized by thick downward strokes and hairline-thin upward strokes. The name derives from the early practice of engraving this style of lettering directly onto smooth copper plates, using a burin or stylus. The plate was inked and the ink was cleaned from the plate, leaving ink in the depressions created by the calligrapher. The plate was then pressed onto a sheet of paper. This printing process is known as *intaglio*.

This book will teach you how to make the lovely letter forms invented by the intaglio engravers. We will take you step-by-step through all the necessary strokes, show you how to assemble these strokes into letters, and then how to assemble these letters into words. Practical exercises are provided at every step of the way. We recommend that you practice these diligently. If success is not immediate, don't be discouraged. Even professional calligraphers, adept in the use of the flat nib, have trouble transferring their skills to the flexible copperplate point. Sometimes, progress will be slow, or seem to be nonexistent. These are natural plateaus, where you must take heart and practice even harder, always concentrating on the basic forms. Sometimes a change of pen point or ink color will give you the courage to move forward.

Copperplate lettering is a demanding skill, but also a highly rewarding one. No matter how you use this newly acquired ability, whether commercially or just for personal correspondence, a beautiful copperplate hand will give joy to yourself as well as to others.

Getting Started

NECESSARY MATERIALS

Pen holder and nibs. For the right-handed student we recommend Mitchell copperplate pen points (made by Cumberland Graphics, Ltd., London), which are usually sold on a card of ten with a pen holder. These are elbow oblique points, which aid in achieving the proper angle. Most left-handers and some right-handers prefer a straight flexible nib, such as the Gillott #303 extra fine. A flexible point is used in order to achieve the desired contrast of thick and hairline-thin strokes. Difficult to obtain, but quite useful, is an oblique pen holder, which allows a right-hander to use any flexible fine point and still have the advantages of the elbow nib. Osmiroid makes a copperplate point to be used with their fountain pens. It is convenient, neat and compact, but you cannot get as fine a result as with a dip point. Only non-waterproof ink will flow properly through these fountain pens.

Inks. We find Higgins Eternal Black to be of satisfactory consistency and color. You may want to buy other colors of ink as well.

Paper. Smooth paper is necessary so that the point will not snag or pick up fibers, thereby making the ink spatter or smear. 16# Hammermill bond paper in a pad is smooth, and translucent enough to be used with a guide sheet.

MAKING A GUIDE SHEET

A guide sheet is a piece of paper darkly ruled with horizontal and diagonal lines which, when placed beneath a translucent sheet of practice paper, will aid the student in forming well-proportioned letters. Each row on a guide sheet consists of four horizontal

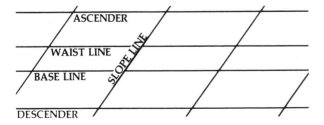

lines (see figure): the ascender, waist line, base line and descender. The space between the lines is allocated in the proportion 3:2:3, from top to bottom. Guide sheets with rows of various heights, constructed according to this proportion, will be found at the end of this book. Memorize the names of the guide lines, since we will be using them constantly. Guide sheets are also ruled with diagonal lines, which make a 54-degree angle with the horizontal. This is the generally accepted slope for copperplate letters.

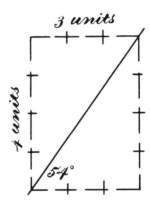

Whether or not you use the guide sheets provided in this book, you will want to learn how to construct your own. Drawing the four horizontal lines is easy; be sure that they are perfectly parallel, and that you have observed the 3:2:3 proportion. A number of methods may be used for drawing the diagonals. A protractor or adjustable triangle, placed along the descender, will give you the desired angle. An alternate method of constructing this angle is to draw a rectangle with the horizontal side being three units and the vertical side being four units (see figure). A diagonal drawn across this rectangle will make an angle of the desired size.

Once you have the 54-degree angle, it is a simple procedure to draw more diagonals parallel to it. Place the long side (*hypotenuse*) of any triangle along the diagonal you have drawn, and a straight edge

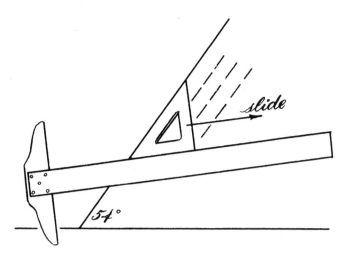

along the bottom edge of the triangle. As the triangle is slid along the straight edge (see figure), additional diagonals can be drawn using the hypotenuse.

PREPARATION

If you will be using a practice pad, place the desired guide sheet under the first page of the pad. If you will be using loose practice pages, they should be fastened to the guide sheets with paper clips or masking tape. When using loose sheets, it is important to make sure that the work rests on a smooth, firm surface.

Fit a nib into the pen holder. When using a new point for the first time, put it over a match flame for a second or two, or apply some saliva and wipe dry. This is done to remove the manufacturer's protective oil.

Have a rag or some tissues handy to wipe the point, and scrap paper nearby to test the point at regular intervals. No matter how good the paper you use, you may occasionally catch a hair fiber in your nib, and this must be removed before you can continue. You should also keep a sheet of paper under your hand to protect the surface of your work from body oils.

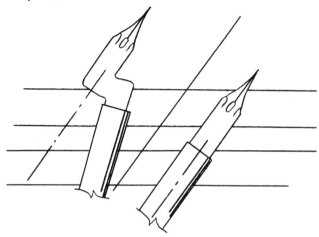

Both left-hander and right-hander should hold the pen between the thumb and forefinger, resting on the middle finger. The side of your hand rests on the paper. The axis of the nib must be parallel to the slope line (see figure). If you are a left-hander and are accustomed to turning your hand so that the pen points downward, you must adjust your grip. As you practice the forms you will understand the absolute necessity of having your pen face upwards. Please take heart and make the effort.

Basic Strokes

Now that we are ready to begin, it is important to keep these basic rules in mind:

1. All downward strokes are thick.
2. All upward strokes are thin.
3. All straight lines are perfectly straight.
4. All curves are round and equal.
5. All loops are equal in size and shape.
6. All endings are straight lines.

In this chapter we will describe in detail the nine basic strokes that will enable you to form nearly all the lower-case letters, or *minuscules*. These strokes will vary in size when we discuss particular letters. Before attempting to execute any stroke, read the entire description of the moves involved and try to visualize in your mind the action of your pen. When the steps are clear to you, then try the basic stroke. When you have completed several attempts, reread the text and compare your results. You may have to do this several times before you understand the structure of the stroke.

After you have placed the guide sheet under your work paper, dip the pen point into the ink so that a quantity of ink covers the hole in the nib. Tap the nib on the rim of the ink container to remove any excess accumulation. Test the point on scrap paper by drawing a few lines. Now you are ready to begin.

Here are the nine basic strokes. (We will discuss additional pen movements as they become necessary in the actual drawing of the letters.)

BASIC STROKE 1

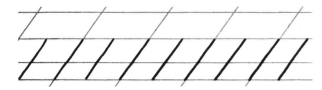

Place the point at the ascender line and apply pressure. Hold for a moment to set a square end and then start to pull the point slowly down at an angle parallel to the slope line. Retain even pressure until the stroke is completed at the base line, pause and then release. The line must be straight and of even

thickness throughout. The top and bottom should be square.

Unevenness in the stroke may be due to unfamiliarity with the pen, nervousness, rushing or an uneven tempo. Although this is script, the letters must be *drawn* slowly. Try it again and be sure to begin to apply pressure *before* you move the pen. Practice this stroke several times before proceeding.

BASIC STROKE 2

Place your point at the waist line. Apply pressure and hold for a moment. Pull the point slowly down, parallel to the slope line. About three-fourths of the way down, gradually lessen the pressure; at the same time begin to curve the line to the right. By the time you reach the base line all pressure should have been released. Continue the stroke around and upward in a counterclockwise direction, until its end is also parallel to the slope line and halfway up to the waist line. If you have drawn it correctly, the bottom of this basic stroke should be tangent to the base line and resemble the handle of an umbrella or an upside-down candy cane. A perfect circle should be able to fit comfortably in it.

You may find that at first the transition between the heavy and thin parts of the basic stroke is not smooth or that the curve is not round enough. Be assured that improvement will come with practice.

BASIC STROKE 3

This stroke is the reverse of stroke 2. Place the point halfway between the waist line and the base line. Applying only the lightest pressure, draw a

straight upward line, parallel to the slope. As you approach the waist line begin to curve your line in a clockwise direction. Then, as you create a tangent at the waist line, gradually apply pressure in the curve until you have achieved full pressure about one-fourth of the way down. Continue the stroke with full pressure along a straight line parallel to the slope. At the base line hold for a moment and then release completely. Again, a circle should fit into the top curve; in fact, basic strokes 2 and 3 should be identical in size, shape and weight.

BASIC STROKE 4

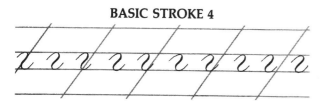

This stroke is a combination of basic strokes 2 and 3. Begin as you did for stroke 3 and end as you did for stroke 2. The two curves in this basic stroke are identical; upside down it looks the same.

BASIC STROKE 5

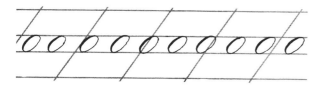

The oval is different from the previous strokes, but remember that the curves are the same size as in basic strokes 2, 3 and 4, and the axis of the oval is parallel to the slope line.

Imagine a clock face. Place your point at the two o'clock position. Start a counterclockwise curve equal in size and shape to the other curves described, applying minimum pressure. Continue in this direction upward toward twelve o'clock. At that position begin to apply pressure and, as you continue around, gradually increase it, achieving maximum pressure at the nine o'clock position. Now continue as in basic stroke 2, but instead of ending halfway up with a straight line, continue to enclose the oval.

Take your time throughout, and resist the temptation to increase your speed. Maintain a slow, steady rhythm.

BASIC STROKE 6

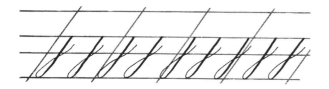

The *j* stroke begins at the waist line. Apply pressure and hold for a moment. Then pull the point slowly down, parallel to the slope line. Continue past

the base line toward the descender line. About three-fourths of the way down begin to release pressure and at the same time curve until the point touches the descender with no pressure. Continue upward, crossing the heavy part of the stroke just *below* the base line and extending the stroke halfway to the waist line. Here we refer you to the diagram. Notice that the upward part of the stroke resembles a section of a figure eight, and that the loop formed is narrower than our curved stroke. For esthetic reasons the cross is made below the base line. Notice also that the reverse curve in the upward part of the stroke is very slight.

BASIC STROKE 7

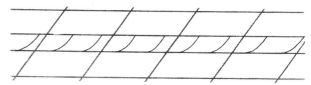

Stroke 7 is an upward stroke, therefore made with minimum pressure. Place your pen at the base line. Draw a line which curves gently upward, at a slightly steeper angle than our slope, until it reaches the waist line.

BASIC STROKE 8

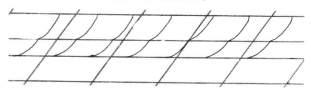

This stroke is the same as basic stroke 7 with an additional arc, which begins at the waist line and ends at the ascender, and maintains the same angle.

BASIC STROKE 9

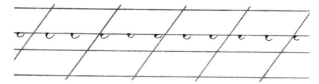

We call this the teardrop. It is formed by applying pressure with the pen to form a small puddle of ink, and then releasing pressure, while making a hairline tail that curves gently around like the bottom part of a small circle. Teardrops should be tasteful, uniform and not overly ornate. Practice this stroke slightly below the waist line.

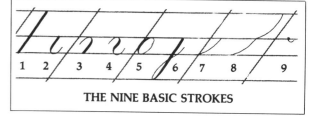

THE NINE BASIC STROKES

Minuscules

We have grouped the *minuscules* (lower-case letters) into families that have similar strokes, leaving those that require more explanation to the end. Remember, when using two or more strokes together in a letter, they should barely touch. Practice a line of each letter as it is explained.

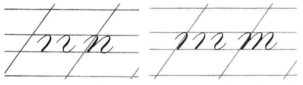

Both the *n* and the *m* are combinations of basic strokes 2 and 3. The strokes connect naturally and are the same size.

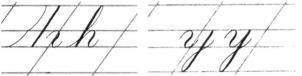

The *h* is a combination of basic strokes 8, 1 and 4. The *y* is a combination of basic strokes 4 and 6.

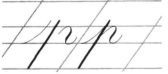

The *p* starts with basic stroke 7, which here extends approximately one-third of the way up past the waist line. At this point you continue downward with basic stroke 1 to the descender. Add basic stroke 4 to complete the letter.

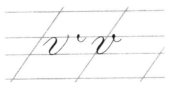

Begin the letter *v* with basic stroke 4. The final portion is continued slightly farther, extending to the waist line or just a hair above. This letter is finished off with basic stroke 9.

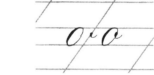

The *o* is made by combining basic stroke 5 with basic stroke 9, which is placed at the finishing point of the oval.

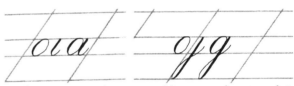

The *a* is a combination of basic strokes 5 and 2. The *g* is a combination of basic strokes 5 and 6.

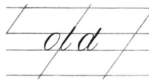

The *d* is a combination of basic stroke 5 and basic stroke 2, which here begins one-third of the way above the waist line.

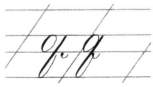

The *q* is a combination of basic stroke 5 and a solid downstroke, as in basic stroke 1. After making an oval, place the pen as you would for the *a* and draw a bold stroke down parallel to the slope line. Before reaching the descender ease pressure and start to curve, as in basic stroke 2 (only narrower). Continue upward toward the heavy line, hitting it just below the base line. Finish by adding basic stroke 9.

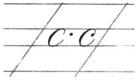

The *c* is a modification of basic stroke 5. It is *slightly* narrower at the beginning of the upper portion, and *slightly* wider at the finish. This difference is necessary in order to connect the *c* to the other letters gracefully but it must not be exaggerated. Complete the letter by adding a small ball of ink at the starting position.

The *e* starts with a smaller version of basic stroke 8 and ends as the *c* does, omitting the small solid circle.

The *l* is a combination of basic stroke 8 and an elongated basic stroke 2.

The *b* begins like the letter *l* and ends like the letter *v*.

The *i* is a combination of basic stroke 7 and basic stroke 2. Dot the *i* with a small solid circle, just about halfway between the waist and ascender lines. The dot should be placed along the slope of the *i*.

The *j* is a combination of basic strokes 7 and 6. Dot the *j* as you would the *i*.

The *u* is a combination of basic stroke 7 and basic stroke 2, which is done twice.

The *w* starts as a *u* and ends as a *v*.

The *t* is a combination of basic stroke 7, going above the waist line as in the *p*, and basic stroke 2, starting from that point. Cross the *t* with a small horizontal hairline at the waist line.

The *z* is a letter unlike any of the previous. One way to begin it is to imagine the oval, or basic stroke 5, drawn in reverse. Start at the ten o'clock position and draw it clockwise instead of counterclockwise. When you get to the base line after the heavy downward curve, make a small clockwise loop and draw another longer oval toward the descender. Complete the letter by creating a loop similar to basic stroke 6.

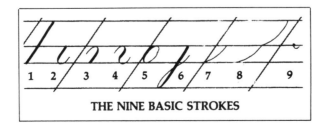

The *s* begins with stroke 7, which here extends above the waist line as in beginning the letter *t*. The second stroke is unique in this alphabet. It retraces the first stroke downward to the waist line, but with minimum pressure. At the waist line pressure is increased quickly and smoothly. The letter takes on a gradual contour, somewhat similar to the first half of the heavy stroke in the *z*. The letter ends with a small ball of ink on the first upstroke. The axis should be parallel to the slope.

1 2 3 4 5 6 7 8 9

THE NINE BASIC STROKES

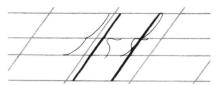

The *f* begins with basic stroke 8, followed by stroke 1, which is brought down to the descender. A fine line (minimum pressure) is then begun at the downstroke from a point between the base line and the waist line. It is unnecessarily complicated to describe so simple a line when a brief study of the diagram makes it quite clear. The cross is made at the waist line.

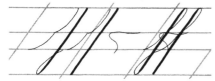

When making a double *f*, start with basic stroke 8, continue with basic stroke 1 and finish off with the end of basic stroke 6 (strokes 1 and 6 overlap). The second *f* starts with basic stroke 8 and continues with a lengthened basic stroke 1. Again, the diagram says it all. The cross from the second *f* begins at the base line, crosses the first *f* diagonally and then crosses both *f*'s at the waist line.

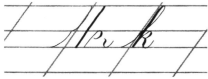

The *k* starts with basic stroke 8, continues with basic stroke 1, and finishes with a modification of basic strokes 5 and 2. After completing the first two basic strokes, retrace number 2, going upward halfway to the waist line. At this point make a small clockwise oval which is just short of closing (top half of space). From the end of the unclosed oval make a smaller version of basic stroke 4, which should fit between that oval and the base line. Start this stroke at the point where pressure begins.

Two different forms of the letter *r* are used by calligraphers and penmen when doing copperplate. One begins with basic stroke 7, which extends just past the waist line. Basic stroke 9 is then made with the tail of it being lightly pulled down to just under the waist line. The next stroke is basic stroke 4, starting where that stroke begins its pressure.

The other *r* begins with basic stroke 3. It continues with basic stroke 7, curving slightly in the opposite direction, extending a fraction above the waist line and ending with basic stroke 9.

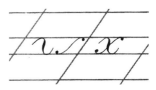

The letter *x* has no precedent. It is a modification of basic stroke 4 except that the angle is changed to about 80 degrees. The second stroke is similar to basic stroke 7, but has reverse curves and a small ball of ink on each end. By itself the second stroke resembles a flattened, lazy *s*. Be sure that it crosses the heavy stroke at the midpoint of each and that the axis of the letter is parallel to the slope.

Now that you know how all the minuscules are drawn, perfection is only a matter of reviewing and practicing them.

Joining Letters

The joining of letters into words is as important as the forming of the letters themselves. A uniform rhythmic flow will enhance the beauty of the entire page and minimize the prominence of any less than perfectly drawn characters.

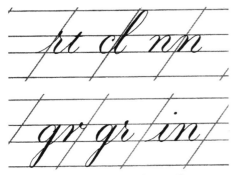

In most cases the minuscules will join naturally because their hairlines connect naturally. In *rt* and *cl*, for instance, one letter continues into the next. The same is true of *gr* and *in*. It would never be incorrect to make all curves the same size. However, if you find it more pleasing you may make the connective curves a little narrower.

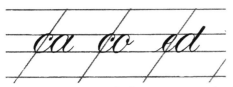

In *ca*, *co* and *ed* draw the letters separately. If you have formed them correctly and spaced them correctly, they will appear to join smoothly.

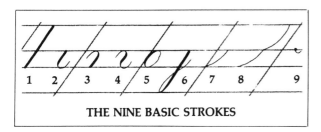

THE NINE BASIC STROKES

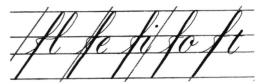

In the case where a letter that ends with a teardrop (basic stroke 9) precedes a letter beginning with an upward hairline, dip the teardrop slightly. In other words, in drawing letters like *i* or *y*, which usually begin with basic strokes 3, 4 or 7, we must eliminate or alter that stroke to accommodate the *v*, *b*, *r* or *w* which precedes them.

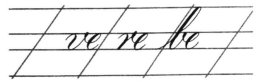

Letters like *v*, *b*, *o*, *r* or *w* before an *e* must dip even lower, to a point halfway between the base line and the waist line. It is understood that you must eliminate part of the basic stroke hairline that normally introduces the *e*.

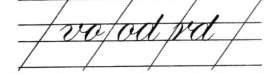

The teardrop letters, when preceding letters based upon the oval (basic stroke 5), are made separately and appear to join.

When connecting from an *f*, eliminate the beginning hairline stroke where previously indicated, and connect from the crossing stroke. Exceptions to this rule are the cases where *f* is followed by an oval, by a *t* or by another *f* (described on p. 11).

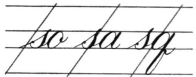

When a letter follows an *s*, just add a conventional hairline where necessary.

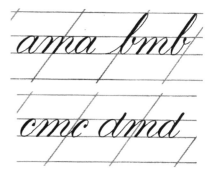

The *x* joins on the first stroke only. The cross is made after the word is completed.

We have now described all possible lower-case letter connections. We suggest the following exercise to familiarize yourself with the joins and to make them second nature to you. Remember that these joins should be as consistent as the letters themselves, so continue to work very slowly. Try the following letter combinations: *ama, bmb, cmc, dmd,* etc. They will cover most connections.

Majuscules

The rules for the *majuscules* (capitals) are generally the same as the rules for the minuscules. Hairlines, drawn with minimum pressure, are the upstrokes, and heavy lines with uniform pressure form the downstrokes. The axes of the capitals follow the 54-degree slope. The letters are uniform in size, their heights stretching from the ascender to the descender lines.

But there are differences. The capitals lend themselves to more freedom and creativity. In practice they all begin and end with hairlines, even when they begin or end on downstrokes. In order to give the letters more grace, start lightly and apply pressure as you continue the stroke downward. Release this pressure before you complete the stroke. This tech-

nique creates what we call *swelled strokes*. These strokes swell and taper gracefully, the widest part being usually in the middle. These thick strokes should not cross each other at their wide points.

To draw the capital letters in copperplate style, we begin with a study of flourishes, as they are an essential part of the upper case. Flourishes are decorative and free in appearance. They are fairly oval in shape; if they are too round they look out of place. If there are two loops, the bottom loop is usually larger.

When the capital is followed by lower-case letters, flourishes are usually drawn on the left side of the capital to allow for better readability.

The figure shows some basic strokes to practice before attempting the capital letters.

Capital letters do not have to connect to lower-case letters, and sometimes it is not even possible to join them. Often, however, they will connect quite naturally. Feel free to use your judgment on this matter.

We provide a variety of examples of the majuscules and suggest that you practice making the letters as shown until you feel that you have developed a steady rhythm and a sensitivity to their forms. After a while you will in all likelihood develop preferences and possibly even create your own variations. While you can and should be free, remember that each letter has its basic structure that should not be violated.

We have again organized the capitals into groups that have similar strokes. We describe only one version of each capital, but the student will come across many styles in this book and elsewhere that he or she should feel free to utilize. In all cases the axis is along the slope line unless otherwise noted.

The *P*, *B* and *R* are constructed in a similar manner. Notice that the *P* begins with a diagonal swelled stroke that curves and ends in a ball. The next stroke begins with a clockwise loop, continues across the waist line, and ends with a ball just above.

The *B* starts like a *P*, but instead of making a little ball, makes a little loop and continues into a clockwise spiral to form the lower part of the letter.

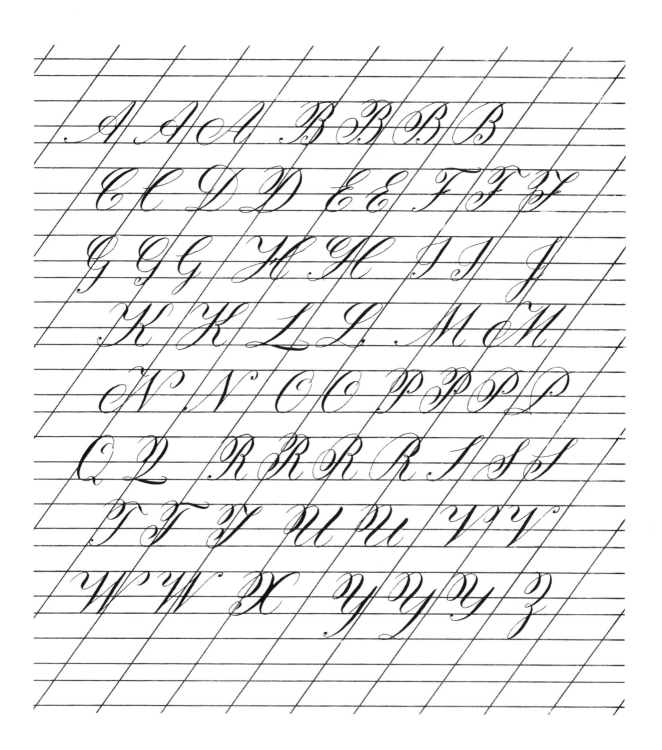

The R is the same as the B, but instead of making a spiral, it finishes with a stroke similar to basic stroke 2.

The I and J are grouped together because their upper parts are similar. The I begins with a clockwise hairline curve, which you can observe in the figure. It ends with a swelled stroke similar to the beginning of the P. The J starts as the I does and ends with basic stroke 6.

The T and F are almost the same except for the small cross-hair stroke on the F. Both start with a clockwise loop which turns up at the end. The vertical stroke is swelled and ends with a clockwise spiral.

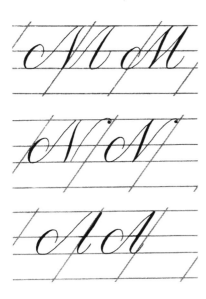

The M, N and A are similar. They each start with a counterclockwise spiral and upward hairline. At the ascender, each has a swelled downstroke. Notice that on the M, the hairlines are parallel and the swelled strokes are parallel. It ends like our basic stroke 2.

The swelled stroke of the N is at a slightly different angle from the M so that its axis will be parallel to the slope line. The second hairline ends with a ball. The A can be constructed by attaching two strokes together, which are similar to the first and last strokes of the M. In this case the first stroke may be steeper than, and the second parallel to, the slope line. The hairline cross is approximately at the waist line.

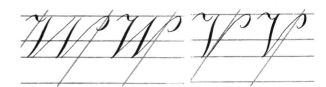

The W and V are similar. The W begins with a wave flourish. The letter itself consists of a pair of parallel heavy downstrokes and a pair of parallel hairline upstrokes, the final one ending in a clockwise spiral. The V begins with the same flourish and first heavy stroke of the W, and ends with the final stroke of the W.

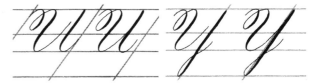

The U and Y are very similar to lower-case u and y, except they are larger and begin with a clockwise loop.

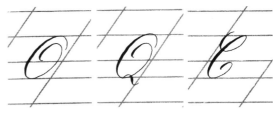

The O, Q and C are based on the oval shape. The O and Q are formed by making a large counterclockwise spiral. The Q has a tail which is similar to the wave stroke. The C starts with a counterclockwise loop and ends in a smaller spiral. Notice that the shape of the C is the same as the left side of the O and Q.

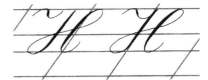

The H begins with a wave flourish and continues with a swelled stroke which is parallel to the slope line. The swelled stroke loops around in a clockwise direction, becomes a hairline, crosses its heavy part at about the waist line, and finishes similar to the C.

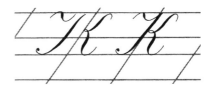

The K begins with the wave and has a swelled stroke like the first stroke of the P. It finishes with a swelled stroke which loops slightly above the center, ending like the R.

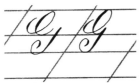

The G begins with a counterclockwise loop rising to a point halfway between the waist line and the ascender. It continues with a swelled stroke, and finishes with a clockwise spiral.

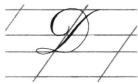

The D is one of the most difficult capitals. It begins with a swelled stroke, loops and continues in a hairline along the base line, and then around in a counterclockwise spiral. The hairline portion after the loop is nearly circular; notice at what point it touches the ascender line and where it crosses the swelled stroke.

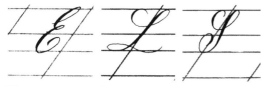

The E starts with a counterclockwise spiral and concludes with another counterclockwise spiral. The

L and S start with counterclockwise loops, then go into swelled strokes of slightly different shapes. The L loops like the D and ends in a hairline. The S ends in a clockwise spiral.

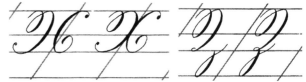

The X starts with a clockwise loop which continues into a spiral, ending in a ball. The next stroke is almost the reverse; it is a counterclockwise spiral with a ball added to the top at completion. The thickest portions of the two strokes should coincide at their centers. It might be a good idea to let the first stroke dry before drawing the second, in order to prevent the ink from spreading. The Z begins with a clockwise loop and ends very much as the lower-case z does.

You should at this point combine upper- and lower-case letters into words. To make this more interesting try writing lines of proper nouns, days of the week, months of the year, states of the union, cities of the world, countries and given names. Continue doing these exercises on the widest of your guide lines, until you feel that most of your recurring errors are eliminated. When you are satisfied with the larger-sized letters, then go on to the smaller. Surprisingly enough, you may at first find it more difficult to work smaller and still keep your pen work even. Remember, practice always helps.

Alaska Bali Crete

Dover Erin Finland

Ghent Hawaii Italy

Japan Kentucky Lido

Montreal Norway

Omaha Paris Quito

Richmond Sparta Tunis

Uruguay Vermont Wales

Xanadu York Zambia

Numerals

There are a variety of ways to write the numerals. We will present two sets for your choice. The numbers follow the same rules as the minuscules and majuscules, in that upward strokes are thin and downward strokes are heavy (unless otherwise indicated). Their axes remain parallel to the slope. You may use whichever style you prefer, but remain consistent.

In the first style all the numbers are the same height as the letter *t*.

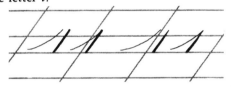

The first stroke in the number *1* is an upward hairline that can begin at *any* point between the base line and the waist line, and that ends at the *t* line (an imaginary line one-third of the way from the waist line to the ascender). The downward stroke should be parallel to the slope and can be made with a heavy even stroke, or a stroke that begins with a point and gradually widens (by increasing pressure) to its thickest width at the base line. Whichever of these variations you may use, remember to use it consistently.

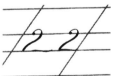

The number *2* starts with a small ball of ink at the waist line, curves to to the *t* line in a hairline stroke and widens with pressure on the downstroke. This resembles the contour of a question mark whose bottom is at the base line. From there we suggest a curved horizontal hairline.

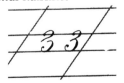

The number *3* begins like the *2* with a ball of ink, but continues with a narrower curve that ends almost halfway between the *t* line and base line. It also resembles a question mark. From there, retrace the curve for a short distance and curve like a backward *o* to the base line and around, ending in a ball.

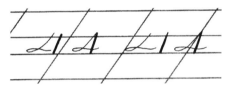

The number *4* starts out like the heavy stroke of the *1*, except that it is more vertical so that the axis of the completed number is along the slope line. You can make it of consistent thickness or make it widen, as described in the *1*. You must leave enough room at the left to accommodate the hair strokes. To make our first hair stroke we come to an exception to the rule; it is made diagonally down with *no* pressure. You may curve it gracefully, if your prefer, to a point approximately three-fourths the way down to the base line. You can create a loop or a point between this stroke and the horizontal hairline (which can also be curved). Some penmen prefer to draw the hairlines first.

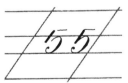

Start at the *t* line for the number *5*; make a heavy stroke parallel to the slope, halfway between the *t* line and the base line. Start a backward oval which will almost touch the waist line, and end like the final stroke on the number *3*. Finish with a horizontal hairline (which may curve), drawn from the starting point.

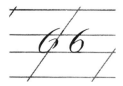

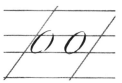

The number *6* starts like basic stroke 5, only beginning at twelve o'clock and raised to the *t* line. You then follow the oval past the base line to the five o'clock position. The second stroke begins in the thickest portion of the oval. Draw a smaller second oval in a clockwise direction, the topmost point of which will be halfway between the *t* line and the base line, and which closes with the first oval to complete the numeral.

The zero can be made with one stroke or two. The first method is simply to draw a large oval the height of the letter *t*. The second method is to start like the number *6* and end like the number *9,*, forming a perfect oval. The zero should be drawn slightly wider than the letter *o*.

Knowing another correct form of drawing the numerals is helpful. In our second set, numbers are drawn the same as the previous set, but some are different sizes and some are positioned differently. The *1, 2* and *0* are the same size and in the same position as a lower-case *a*. The *6* and *8* are the same as in the previous set, being placed between the *t* line and the base line. The *3, 4, 5, 7,* and *9* are the same size as before, but their tops are at the waist line and they extend below the base line the same distance that the *6* and *8* extend above the waist line.

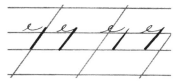

Start the number 7 with a small upward hairline to the *t* line. Then form an extended teardrop stroke, which again touches the *t* line and continues like either variation of the number *1*.

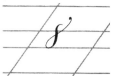

The number *8* can be drawn in one stroke. The heavy part of it is practically perpendicular and resembles somewhat the heavy portion of our lower-case *s*. Begin with a hairline slightly below the *t* line, curve up and around and into the heavy portion. Then change direction and cross upward at the waist line, and proceed past the *t* line. Add a ball of ink. In this case it does not connect to the original starting point. Observe that the bottom loop is larger and wider than the top loop.

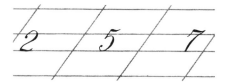

You may wish to try some variations of the basic numbers. Sometimes you will see a heavy horizontal stroke for the *2, 5* and *7*. This can be accomplished by *turning* the pen point or the paper slightly so that pressure can be applied for that stroke only. When drawing a *5* this way the vertical stroke will be drawn in a hairline. At times the downward stroke of the *7* is drawn at a sharper angle. Some penmen feel that the figure balances better this way.

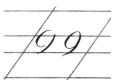

The number *9* can be identical to an upside-down *6*. Begin with part of an oval whose top touches the *t* line and whose bottom is midway between the *t* line and base line. Start retracing at about the one o'clock position in a reverse oval touching the base line.

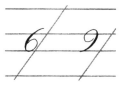

The *6* and *9* can be done in one stroke, with only one side being heavy. This might be preferable when the size of the numbers is quite small. Remember that the shapes remain the same.

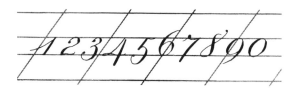

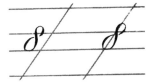

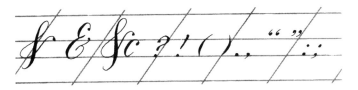

The *8* can be drawn in two strokes. The first stroke is identical to the beginning of the *8* previously described. The second will now start at the top, connecting with the open stroke and following the identical shape of the one-stroke *8*.

Our first variation of the ampersand is made in one stroke, starting above the waist line. Observe the shape in the figure. Apply pressure only at the finish.

The second ampersand resembles a backward *3*, except that the bottom stroke spirals slightly. It fits between the *t* line and base line. Add a small ball of ink, retrace with a curve, and add another small ball of ink.

The abbreviation *etc.* is made using the first ampersand and a small *c*. Punctuation marks are obvious and follow basic rules. See the examples in the diagram.

Further Suggestions

If you have arrived at this point having practiced all the forms and letters as recommended, then your feelings about your progress are probably somewhere between triumph and despair. By now it is likely that you are convinced that this art form is indeed difficult, and again we must suggest that you work hard at it. We believe that one or two hours of practice a day is not excessive, at least until you feel confidence and control. This will certainly take a few weeks at least. A certain amount of shakiness is normal at first, so don't try to overcome it by writing faster.

Aim for perfection but accept slight differences in your hand. These are what lend charm, individuality and personality to your lettering. Although each letter by itself should be beautiful, it is the overall appearance of the page that creates the first and the lasting impression. To test this, look at a completed page sideways and at an angle of about 30 degrees with your line of sight. The page should appear uniformly gray without white "holes." Words should be spaced quite closely together; a small *i*, or no more than than an *o*, should fit comfortably between them. To test your page for rhythm, try looking at your work upside down or from the back with a light behind the page.

The use of a light box will help you to see the guide lines better and permit you to use heavier papers. A light box can be purchased, or a very simple one can be rigged by placing a light bulb between two telephone books. A piece of frosted glass or white plastic is then placed on the books to put you in business.

If you have smeared a letter, but do not wish to redo the work, you may resort to one of several solutions, depending upon the surface you are using. Gentle rubbing with a soft pink eraser will in most instances do the trick. A shadow may remain but be virtually unnoticeable. Cautious scratching with a new razor blade may work, but test this technique first on a scrap of the same paper. Also make sure you can write over the scratched area. Often, though, the work cannot be saved. If the work is intended for photographic reproduction, you may do a number of things. Opaque white paint, available in art supply stores, will cover blemishes. You can also cut out or paste over errors. The perfection of advertising script in print testifies to the success of these methods.

The flexible pen will at times pick up a fiber, and a beginner will often ruin a word by neglecting to remove it in time. Don't make the mistake of trying to complete a word once you have noticed the slightest hair, but wipe your pen immediately. You will soon acquire the knack of being able to stop in the middle of downstroke, clean your pen, and then continue the stroke, leaving not the slightest telltale sign.

Remember to warm up before beginning any session of lettering. This will ensure a constant rhythm when you do get down to work.

Use the best materials. When your hairlines begin to lose their delicateness it is probably time to replace your nib. Have several on hand at all times, as you will find that they are not all identical; you may try one that does not work well or that you do not like.

Some penmen prefer to add gum arabic to their ink to improve the flow. About 12 drops to a bottle should prove sufficient to those sensitive enough to notice a difference.

We hope that not only will your penmanship improve but that you will acquire a taste for the beauty of script in general, including that done in styles other than copperplate. In a short time you will be able to see what is right and wrong with the myriad of styles and forms we see around us and are bombarded with every day. We suggest that you start a file of examples of copperplate you encounter in newspapers, magazines, fliers and correspondence—both good and bad.

Keep working. Remember that no two penmen have the same hand, nor would they desire it. Once you have mastered the basic skill (and a moment will arrive when you realize it), it will never leave you. Like riding a bicycle or swimming, even after a long layoff, all you need is a little warm-up to get you back in the groove and make your copperplate as good as ever.

Glossary

Ascender. Any stroke that goes above the waist line, or any letter which contains that stroke.

Ascender line. The highest point of any stroke in the alphabet.

Axis. An imaginary straight line, around which the letter is balanced.

Base line. The line that the body of the letter sits on.

Contour. The outline of the form.

Descender. Any stroke that goes below the base line or any letter that contains that stroke.

Descender line. The lowest point of any stroke in the alphabet.

Flourish. Decoration, ornament or embellishment.

Majuscule. Upper-case or capital letter.

Minuscule. Lower-case or small letter.

Reverse curve. A curve that changes direction.

Slope line. The angle of slant.

T-line. An imaginary line one-third of the way from the waist line to the ascender (the height of a *t* or *d*).

Waist line. The top line that the body of a letter reaches.

Three different-sized guide sheets, to be placed underneath your writing paper, are provided on the following pages.

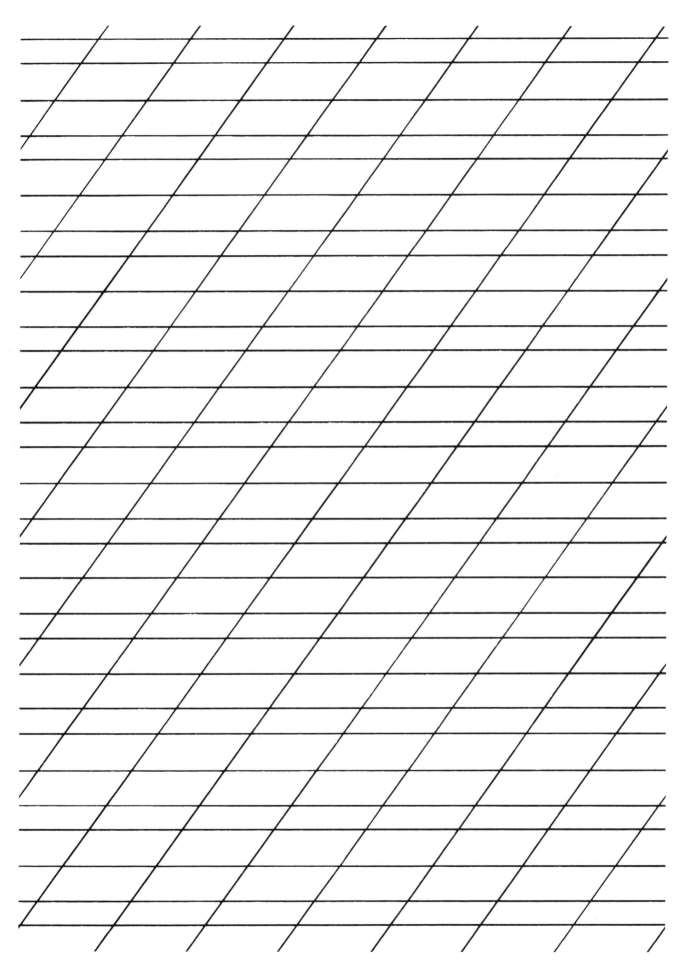

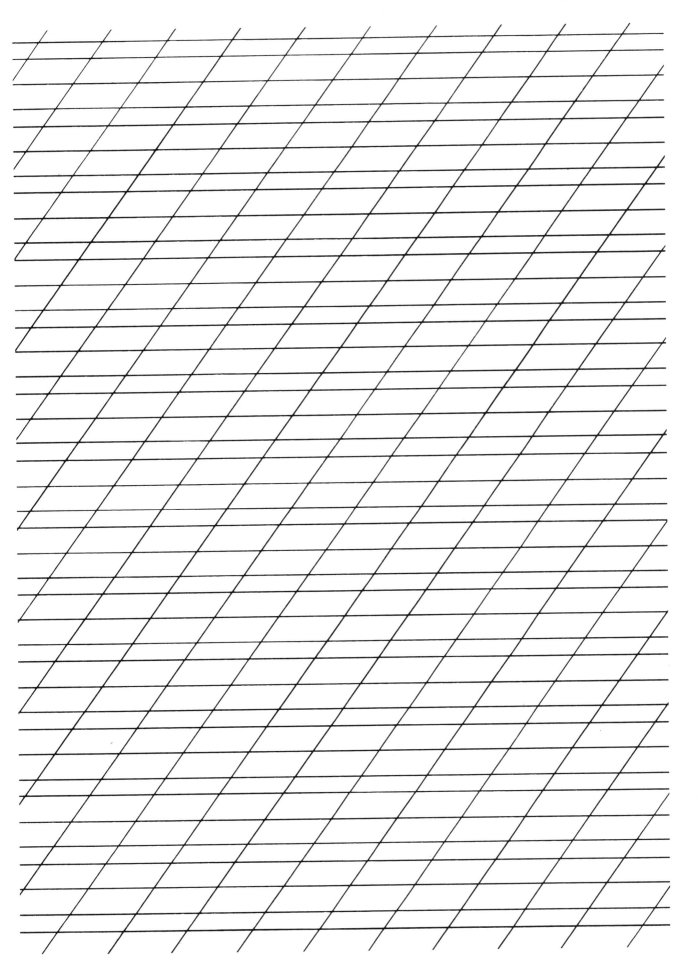

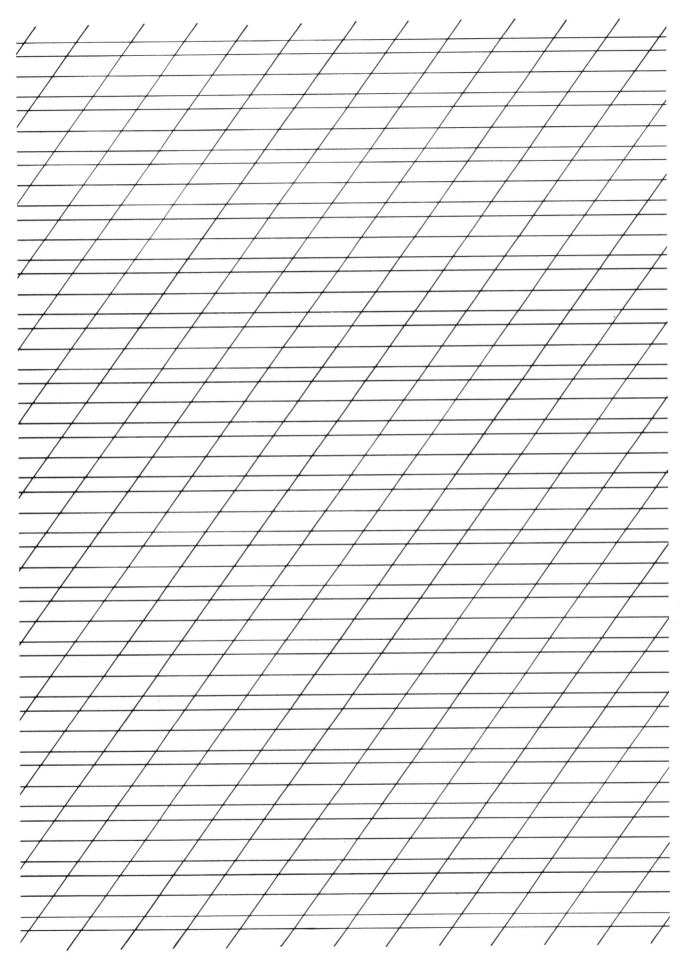